illustration school:
let's draw happy people

sachiko umoto

BEVERLY MASSACHUSETTS

QUARRY BOOKS

First published in the United States of America in 2010 by
Quarry Books, a member of
Quayside Publishing Group
100 Cummings Center
Suite 406-L
Beverly, Massachusetts 01915-6101
Telephone: (978) 282-9590
Fax: (978) 283-2742
www.quarrybooks.com
Visit www.Craftside.Typepad.com for a behind-the-scenes peek at our crafty world!

Library of Congress Cataloging-in-Publication Data

ISBN-13: 978-1-59253-646-7
ISBN-10: 1-59253-646-8

10 9 8 7

Printed in China

to the reader

They say that "learning begins by imitating," so I have filled this book with a lot of illustrations that you can draw by copying. Take your time, look at each illustration one by one, then choose one you like and try tracing or drawing one yourself. Your drawing doesn't have to turn out just like the example, so don't worry if it doesn't turn out exactly the same. Think about how you would draw the picture and arrange its parts any which way you choose!

The trick to enjoying illustration is showing your work to other people. "Don't you think this is cute?" "This is really funny-looking, isn't it?"

Ask your family and friends these questions when you show them your drawings. If even a little bit of what you wanted to express gets across to them each time you show them a drawing, there is no doubt that illustrating will become more and more fun.

Work at your own pace, when you want, where you want. But whatever you do, try your hand at creating a whole bunch of really cute drawings, OK?

Sachiko Umoto

how to enjoy this book

choose one
Look for your favorite character. Ask your friends and family what characters they like.

 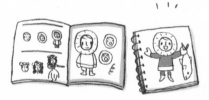

imitate it
Look at the page on the left and use the guide to casually trace what you see.

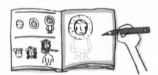

modify it
Try changing the expression of your drawing. You can make different poses, or add different colors.

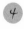 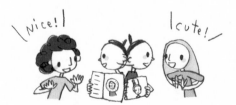

show it
Show your friends and family the pages you have doodled on, or the notebooks and memo pads you have drawn on.

Pencils and Mechanical Pens

If you make a mistake, you can just erase it, so you can draw anything in any way you choose. Apply different pressures to your pencil tip to get a diverse array of lines

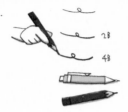

Erasers

Your eraser is a reliable friend you can always count on. Its edges will start to get round as you use it, but that's OK! Simply use a craft knife to carve sharper corners.

Erase with the edges.

Erase a little more than you need to and draw what you lost.

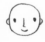

The lines you should erase with your eraser are shown using dotted lines.

Ballpoint Pens and Felt-Tipped Markers

Try drawing the entire picture at once. You won't be able to erase your mistakes, but you can draw things pretty quickly.

Colored Pencils and Colored Felt-Tipped Markers

Coloring can also be a lot of fun. You don't have to color the entire picture. Leave some white space. Wrapping up your drawing with just a few colors can add a really nice finish.

Notebooks, Appointment Books, Memo Pads, Etc.

You can use whatever you can find around you for your canvas. And I recommend doodling, as long as your doodles don't interfere with your studies or your work.

the basics of the basics

Learning some basic skills helps make drawing easy. But, remember, the basics are nothing more than a fundamental starting point.

1. Draw larger shapes first

Draw the head before you draw the eyes or the nose, draw the body before you draw the hands, feet, or other patterns. Try to get a idea of the overall shape before you add the fine details.

2. Draw from top to bottom, right to left

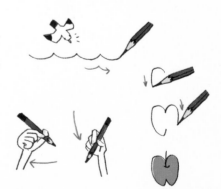

Pick up your pen or pencil and try waving it around. Can you feel how natural it is to move it from top to bottom or right to left? (Or left to right, if you are left-handed!)

3. Draw the head before you draw the body

When you draw the head, you can get a feel for your character's personality and what it is probably thinking at the time. This makes it easier for you to decide how to draw the rest of the body.

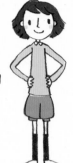

This person looks lively, so she should be wearing sporty short pants and have her hands on her hips.

The Basics Can Be Contradictory

Sometimes the basics described in steps 1, 2, and 3 will seem to contradict each other, and you may have a hard time deciding where to start. If that is the case, just start wherever you want.

After drawing the triangular hat, draw the face

After drawing the face, put the hat on

4. Apply different pressures to the tip of your pen

Press hard when you draw the solid parts and lightly when you draw the soft parts. You can draw a lot of different lines with the same pen just by applying different amounts of pressure.

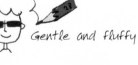

Press down hard Gentle and fluffy

Leave uncolored Gently shade Color in
 with gray strong black

illustration school with happy people

contents

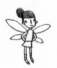

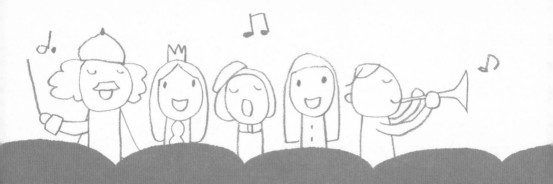

introduction: drawing songs

singing while drawing helps you draw good and strong lines

a boy's song

a girl's song

the prince's song

the princess's song

the king's song

a boy's song

♪1

A round, round moon has
come out, you know.
(Draw the outline of a boy.)

♪2

Two black beans have
fallen into place.
(Draw the eyes.)

♪3

With a sweet smile,
"good afternoon"
(Draw the nose,
mouth, and ears.)

♪4

Well, well, well,
you've grown so tall.
(Draw the trunk.)

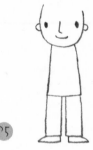

♪5

You've gone and
grown taller again!
(Draw the legs and feet.)

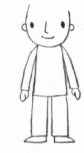

♪6

Stretch both arms down
as far as they will go.
(Draw the arms and hands.)

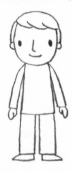

♪7

He didn't want to,
but he went for a haircut
(Draw the hair.)

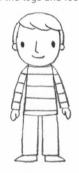

♪8

Draw the stripes and there
you have the boy!
(Draw the pattern on the
T-shirt and it is finished.)

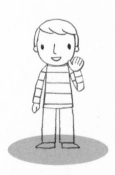

let's draw!

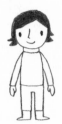

I can't find my clothes

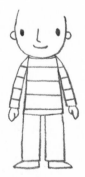

I hate going to the hairdresser!

Hi!

a girl's song

♪1

There's a round, round plate
(Draw the outline of a girl.)

♪2

Watermelon seeds
have fallen into place.
(Draw the eyes.)

♪3

With a sweet smile she's
in such a good mood.
(Draw the mouth and nose.)

♪4

A triangular dress
makes her look so chic.
(Draw the trunk.)

♪5

She really likes the
little shoes, as well.
(Draw the legs.)

♪6

She always has
the proper posture.
(Draw the arms and hands.)

♪7

She also likes long hair.
(Draw the hair.)

♪8

Add the buttons, and
there you have the girl!
(Draw the buttons and the
hair bangs, and it's finished.)

let's draw!

 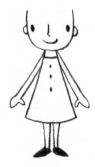

I need some new clothes!

I want to change my hairstyle.

Nice to meet you!

♪1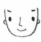

A boy with manly eyebrows.
(Draw a boy's face.)

♪2

His pageboy cut
makes his face so cute.
(Draw the hairstyle.)

♪3

He's wearing a hat
aslant on his head.
(Draw a beret.)

♪4

Triangular top and round pants
(Draw the trunk and pants.)

♪5

Long and slender legs
(Draw the legs.)

♪6

Draw the arms
stretching straight down.
(Draw the arms and hands.)

♪9

Add some stylish decorations.
(Draw some decorations
on the neck and shoes.)

♪8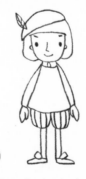

Put a feather in the hat
and a prince appears!
(Draw some vertical stripes
on the pants and put a feather
in the hat, and it is finished.)

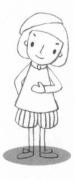

let's draw!

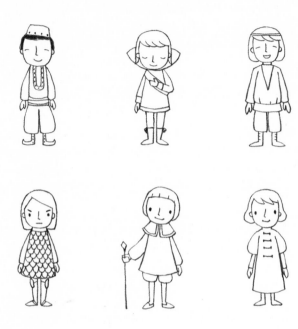

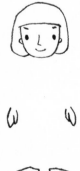
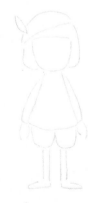

It looks like he wants to wear some new clothes! It looks like he wants to change his hairstyle! The Prince has arrived!

the princess's song

 ♪1

The sweet smile of a girl
(Draw a girl's face.)

 ♪2

Long hair parted in the middle
(Draw the hairstyle.)

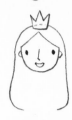 ♪3

A small crown is shining.
(Draw a crown on top
of her head.)

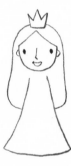 ♪4

The pretty dress is
triangular shaped.
(Draw the dress.)

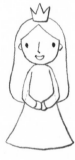 ♪5

Both hands are
gently clasped together.
(Draw the arms.)

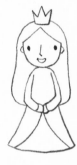 ♪6

Let's give the dress a pattern.
(Draw a decorative skirt.)

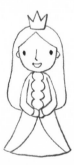 ♪7

Add a fluffy touch to the dress.
(Draw a design on the dress.)

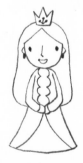 ♪8

Once the crest has
been added the princess
makes her appearance!
(Draw a crest on the crown and
earrings, and it is finished.)

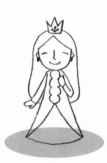

let's draw!

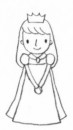 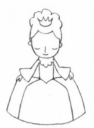 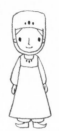

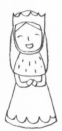 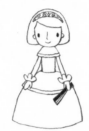 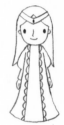

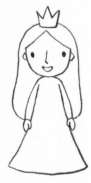 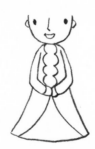

She says she wants to wear a new dress!

She says she wants a new hairstyle!

The Princess has arrived!

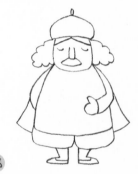

the king's song

 ♪1

I have thought long and deep.
(Draw the king's face.)

 ♪2

A swirling steam is rising.
(Draw the hairstyle.)

 ♪3

And a big chestnut is on the top.
(Draw the king's crown.)

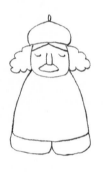 **♪4**

A big stomach and rounded pants
(Draw the trunk and pants.)

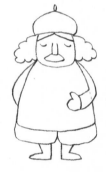 **♪5**

How does my stomach look?
(Draw the hands and feet.)

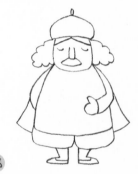 **♪6**

Where are my cloak and shoes?
(Draw his cloak and shoes.)

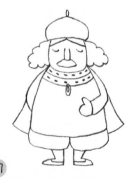 **♪7**

Where is the pendant that
I am so proud of?
(Draw the pendant on the
decoration around his neck.)

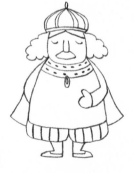 **♪8**

Draw the stripes and the
king shows his presence!
(Add the vertical stripes to the
king's pants and crown,
and it's finished.)

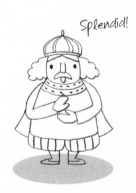

Splendid!

let's draw!

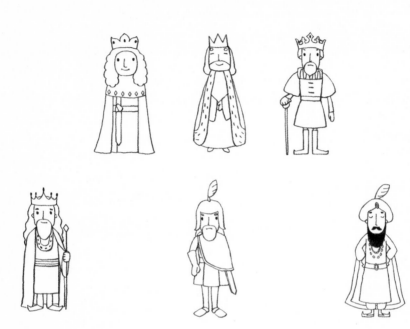

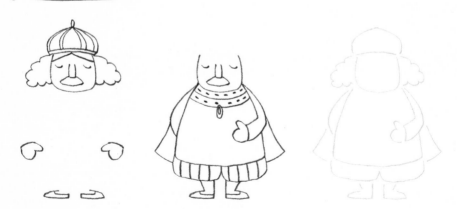

The king requires a change of clothes!

It appears that the king does not like his hairstyle!

drawing various expressions

Let's try to convey various emotions by drawing different expressions.
You can create a number of different expressions by varying the shape of the
eyes and mouth and the direction the face is looking.

faces seen from the front

I did it!

This is fun!

Ha, ha, ha!

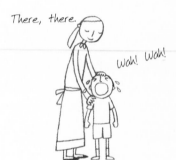
There, there.

Wah! Wah!

I'm so happy!

Smile

Embarrassed giggle

Yawn

Peacefully asleep

What?!

Tee hee!

Sorry, sorry

Screech!

I'm angry!

I hate this.

Oh no! Wah! Wah!

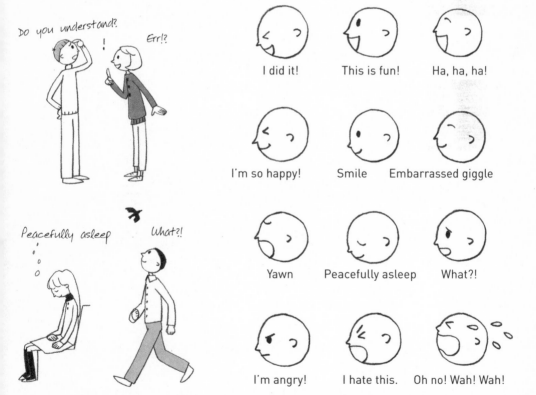

chapter 1 family

*if you imagine your family while drawing,
you may be surprised to find that your pictures
will strangely resemble each family member.*

a lively mother / a kind mother
a stylish father / a plump father
gorgeous big sister / cute little sister
handsome elder brother / naughty younger brother
relaxed grandmother / wise grandfather
crawling baby / toddling baby

a lively mother

Clothes that are easy to move in suit mothers who are always lively.

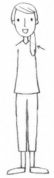

It is easier to decide where to start drawing the arms if you draw the shoulders and sides at the same time.

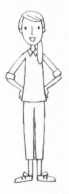

1. Draw a cheerful expression and a tied-back hairstyle.

2. Draw the body and the pants and then the legs.

3. After drawing the collar, place the hands on the hips and, finally, draw the rolled-up sleeves on the arms.

a kind mother

Relaxing designs suit mothers who are always kind.

Draw two same-shaped hands and overlap them

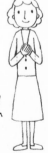

1. Draw a benign-looking face and lightly permed hair.

2. Draw the body and the skirt and then the legs.

3. Draw the buttons and gently clasp the hands.

let's draw!

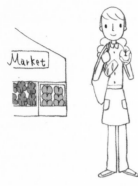

Eco-bag

A mother busy shopping

A lively mother

One-pot stew

Mother's belongings

A kind mother

a stylish father

The chic glasses worn by this stylish father really suit him.

Decide where the parting for the fringe should be.

Shift the glasses a little to show the eyes

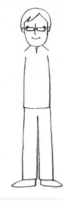

Both arms are crossed in this way.

The left arm in front.

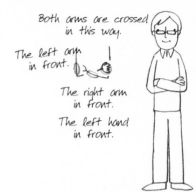

The right arm in front.

The left hand in front.

1. Draw a gentle expression, a hairstyle, and stylish glasses.

2. Draw a slim body and then the pants and shoes.

3. Draw the collar and folded arms.

a plump father

A large-bodied father looks strong and solid, as if he could protect you from anything.

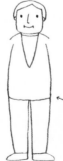

There is extra flesh around the bottom and stomach giving him a bottom-heavy shape.

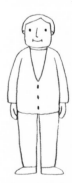

1. Draw a chubby face and the hair.

2. Dress his large body in a cardigan and draw his pants and shoes.

3. After drawing his arms, let's button-up his cardigan.

let's draw!

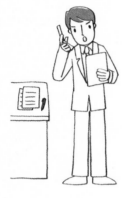

Father working

What father carries

Documents

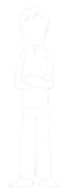
A stylish father

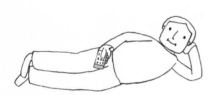

Sunday father

Glasses

newspaper

A plump father

gorgeous big sister

Gorgeous big sister is always aware of what is stylish.

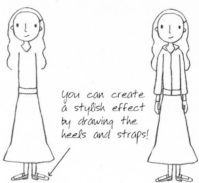

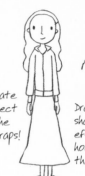

You can create a stylish effect by drawing the heels and straps!

Draw a triangular shape to give the effect of the hood resting on the shoulders.

1. Give her a nonchalant expression and long hair with a slight wave.

2. Draw a slender body, a long skirt, and stylish shoes.

3. Draw her slim arms and the collar of her hooded jacket.

cute little sister

Cute little sister insists on wearing only the clothes she likes.

If you position the eyes lower down on the face it creates a childish look

Add some pretty lace on the hem of the skirt.

1. Draw a childish expression and short hair with short bangs.

2. Draw a small body, a layered skirt, and shoes.

3. Draw the arms and give her some shoes. Finally, draw a heart on the T-shirt.

let's draw!

Older sister unwinding

Her possessions

A broach

Boots

Gorgeous big sister

Little sister's possessions

Candy

Wah! Wah! Wah!

Teddy bear

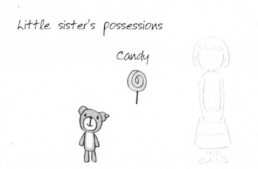

Cute little sister

handsome elder brother

The handsome elder brother always looks smart.

Well-defined eyebrows give the face a masculine appearance.

Each hair is a simple line.

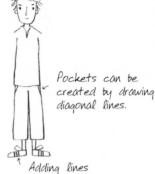

Pockets can be created by drawing diagonal lines.

Adding lines creates style!

The collar of the polo shirt is small and square.

1. Draw a manly expression and silky hair.

2. Draw the body, pants with pockets, and sneakers.

3. Draw long-sleeves with large hands and the collar of the polo shirt.

naughty younger brother

The naughty younger brother is always wearing short-sleeves and shorts.

Draw a line and create an accent

1. Draw a cheerful, lively expression and short hair.

2. Draw a slim body, shorts, and the legs.

3. Draw the arms. The fists are clenched.

let's draw!

Street boy

Elder brother's possessions

Headphones

Camera

Handsome elder brother

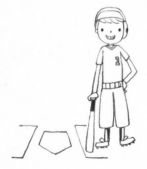

younger brother plays
Little League

younger brother's possessions

Ball

Glove

Naughty younger brother

relaxed grandmother

A relaxed grandmother does not move for anything.

Tie back the plumped-up hair.

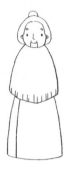

Use a pin to fix the wraparound skirt.

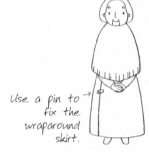

1. Draw a gentle face and hair tied up in a bun.

2. Draw a loose cape and a wraparound skirt.

3. Fold her hands together in front and give her some shoes.

wise grandfather

Grandfather is the advisor and has grown a splendid beard.

His eyebrows are white as well.

Draw the extent of his beard from the chin-line.

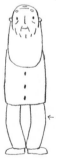

He's a little bow-legged.

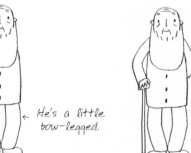

1. Add some wrinkles to his face and draw a full beard.

2. Draw his body and his slightly bowed legs.

3. Give him a walking stick to hold, and draw the buttons on his jacket.

let's draw!

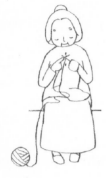

Grandmother knitting

Grandmother's favorite

A blanket to keep
the knees warm

Relaxed grandmother

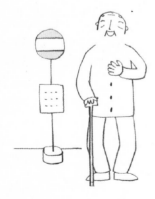

Grandfather going out

Grandfather's favorite

Green tea

Wise grandfather

crawling baby

Babies use their whole bodies to gradually move forward.

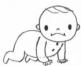

The knees and palms of the hands are touching the floor.

1. Draw a round face and plump cheeks.

2. Draw a plump stomach and rounded back.

3. Draw plump hands and feet and add buttons.

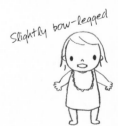

toddling baby

The baby stands up firmly on little legs.

Draw the upper lip.

Draw the lower lip.

The point to accentuate is the plump cheeks.

Slightly bow-legged

1. Draw the round face and the hair that has grown a little.

2. Draw the dress and legs.

3. Draw the arms that help to keep the balance.

let's draw!

Baby's possession

A cradle

Crawling baby

Mobile

Duck toy

Toddling baby

consider the poses from the bones

When drawing the whole body, try to think roughly about the balance of all of the bones and the location of the joints. If you plan the pose starting from the bones you may be surprised to find that you can draw even difficult poses.

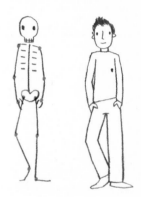

When you are leaning to the left,
the bones look something like this.

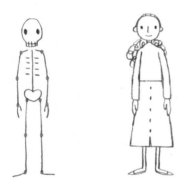

When you are standing,
the bones look something like this.

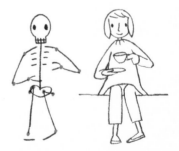

When you are drinking tea,
the bones look something like this.

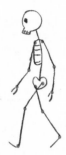 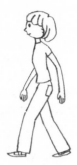

When you are walking,
the bones look something like this.

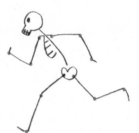

When you are running,
the bones look something like this.

Wheeze! Wheeze!

When taking a rest,
the bones look something like this.

chapter 2 working people

imagine various professions and try to completely immerse yourself in the job they are doing when you draw the people working.

nurse / doctor

flight attendant / pilot

waitress / chef

businesswoman / businessman

police officer / firefighter

model / fashion designer

florist / cake maker

baseballplayer / soccer player

teacher / artist

astronaut / explorer

nurse

In her white uniform, with a kind face and attention to details, she is just like an angel. She helps us endure injections, as well.

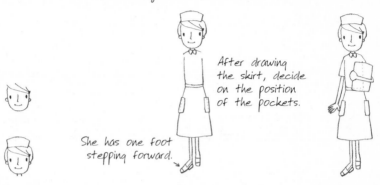

After drawing the skirt, decide on the position of the pockets.

She has one foot stepping forward.

1. Draw the smiling face, the hair fastened with a clip, and her nurse's cap.

2. Draw her body dressed in a white uniform, her skirt, and her shoes.

3. Give her a patient's file to carry.

doctor

You feel so relieved when you are examined by a trustworthy doctor. He looks like you could soon become friends with him.

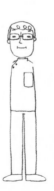
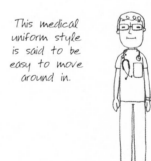

This medical uniform style is said to be easy to move around in.

1. Draw a kind face, curly hair, and glasses.

2. Draw his body dressed in a white uniform, his pants, and his shoes.

3. Draw his hands and a stethoscope around his neck.

let's draw!

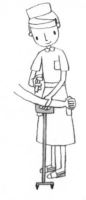

Nurse's possessions

A thermometer

Patients' files

Medicine

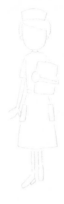

It's just a little prick

Let's draw a nurse!

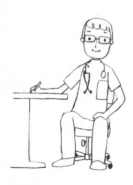

Doctor's possessions

A stethoscope

What's the problem?

Let's draw a doctor!

flight attendant

Flight attendants are professionals who pay close attention to service. Many people aspire to do their job.

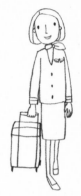

1. Draw her face, hairstyle, and a stylish scarf.

2. Draw her body dressed in a uniform, her skirt, and her legs.

3. Give her a suitcase to pull along and pin a badge to her chest.

pilot

Pilots have to become skilled in controlling the difficult maneuvers of airplanes. His uniform is always smart.

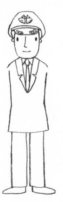
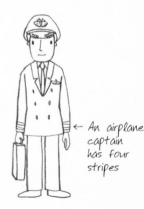

The emblem on his badge is birds and leaves.

← An airplane captain has four stripes

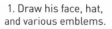

1. Draw his face, hat, and various emblems.

2. Draw his body in uniform, his pants, and his shoes.

3. Give him a bag to carry and a badge on his chest.

let's draw!

What flight attendants carry

Airline meals

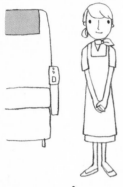

Please fasten
your seat belts.

Pull-along luggage

Let's draw a
flight attendant.

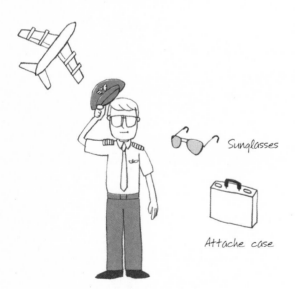

Sunglasses

Attache case

Have a pleasant flight!

Let's draw a pilot.

waitress

She has to memorize lots of orders all at once and bring many meals to the tables at the same time.

Pull her hair back tightly.

Holding the tray right in the middle gives it a stable balance.

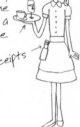

Receipts

1. Draw a cute face and tied-back hair.

2. Draw her body dressed in a uniform, her skirt, and her legs.

3. Give her a tray to carry and put the receipt pad in her pocket.

chef

He is always wearing the chef's jacket that enables him to easily cook dishes hygienically.

He has a round face that looks used to eating delicious food.

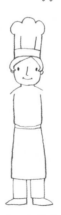

He wears a long apron.

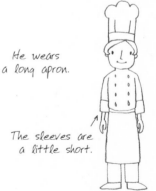

The sleeves are a little short.

1. Draw the round face, his hairstyle, and his chef's hat.

2. Draw the chef's body in a jacket, apron, pants, and shoes.

3. Draw the sleeves, a little short, and the hands.

let's draw!

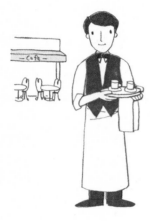

Waiter

What the waitress carries

 Iced water

 A tray

Let's draw a waitress.

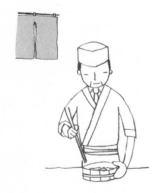

A sushi chef

A chef's implements

 A knife

 A frying pan

Let's draw a chef.

businesswoman

Regardless of how hard the work is, she carries it out energetically and with a smile.

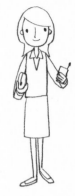

1. Draw the face and hairstyle.

2. Draw her body in a suit, her skirt, and her legs.

3. Put a clutch-bag in one hand and a mobile phone in the other.

businessman

In the heat or in the cold, every day he puts on a suit and diligently completes his work.

Give him a snappy hairstyle.

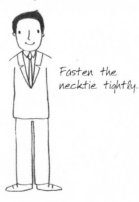

Fasten the necktie tightly.

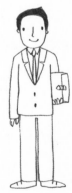

1. Draw her face and hairstyle.

2. Draw him wearing a suit and trousers.

3. Give him some documents to carry under his arm.

let's draw!

What the career woman carries

Her packed lunch

Her schedule book

Let's draw a career woman.

What the businessman carries

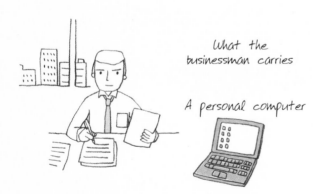

A personal computer

Let's draw a businessman.

police officer

He patrols the streets every day to protect the safety of our town.

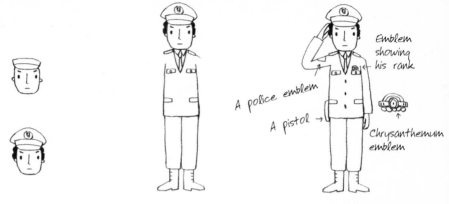

Emblem showing his rank

A police emblem

A pistol →

Chrysanthemum emblem

1. Draw his face, hat, and hair.

2. Draw his body in a uniform, his pants, and his shoes.

3. Draw his hands, add the pistol, and badges.

fireman

In preparation for fire-fighting he undertakes strict training.

Emblem on his helmet
Snow crystal

Leaves

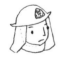

The area around his neck is protected as well

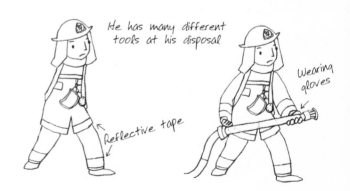

He has many different tools at his disposal

Wearing gloves

Reflective tape

1. Draw the face and helmet.

2. Draw the upper part of the fireman's uniform, the pants, shoes, and equipment.

3. Put a hose in his hands.

let's draw!

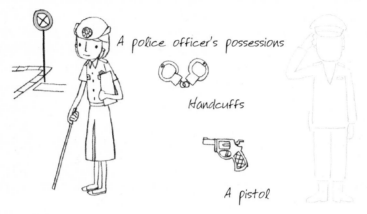

A police officer's possessions

Handcuffs

A pistol

A female police officer

Let's draw a police officer.

Things held by a fireman

A fire extinguisher

Let's draw a fireman.

A rescue worker

model

She has a style that anyone would long to have and looks good in any kind of clothes. I'm so envious!

Make her look stylish by sweeping her hair to one side.

Notice that her head is small.

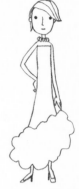

1. Draw a small head and a stylish hairstyle.

2. Draw the dress and necklace.

3. Create a good pose with the positioning of his hands and feet.

fashion designer

He's always thinking of ideas for new designs.

His hairstyle follows the contours of his face.

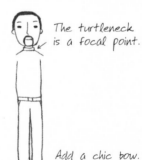

The turtleneck is a focal point.

Add a chic bow.

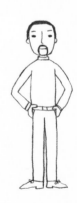

1. Draw his face, hair, and moustache.

2. Draw his body in a shirt, pants, and shoes.

3. Put both his hands on his hips.

let's draw!

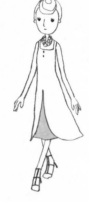

A model's possessions

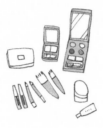

Makeup kit

A model walking

Let's draw a model.

A designer's possessions

A sewing machine

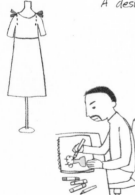

A tape measure

A designer in the middle of his work

Let's draw a fashion designer.

florist

She has to handle many flowers so she wears a light outfit that is easy to move around in.

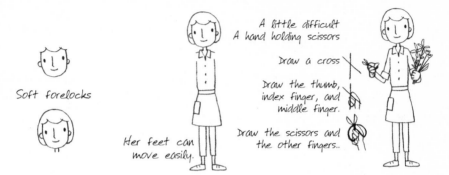

Soft forelocks

A little difficult
A hand holding scissors

Draw a cross

Draw the thumb, index finger, and middle finger.

Draw the scissors and the other fingers..

Her feet can move easily.

1. Draw the face and hairstyle.

2. Draw the body and apron, pants, and shoes.

3. Give her some flowers and scissors to hold.

cake maker

Cake makers must love sweet things.

Draw the face with a clear outline.

After that you can erase some lines.

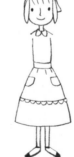

She is holding a box in both hands.

The apron and shoes are cute.

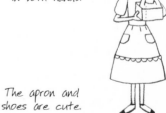

1. Draw the face and hairstyle and head scarf.

2. Draw the body with the skirt and apron and the legs with shoes.

3. Give her a cake box to hold.

let's draw!

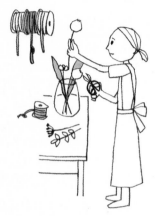

Things found at the florist

Flowers

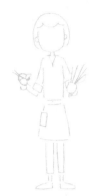

Such lovely flowers have come in.

Let's draw a florist.

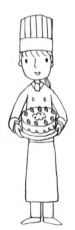

Things found at the cake shop

Cakes

Cookies

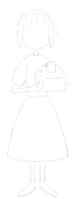

A freshly baked cake is ready!

Let's draw a cake maker.

baseball player

There are two designs to consider—home uniforms and visitors' uniforms.

Draw the visor and helmet.

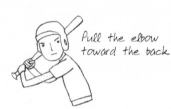

Pull the elbow toward the back

The face is facing front and the body to the left.

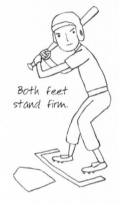

Both feet stand firm.

1. Draw the face and helmet.

2. Draw the body and both arms with the bat.

3. Draw the two feet standing firm and his spikes.

soccer player

To build a good sporting relationship the players often exchange uniforms after a match.

The hair is pulled back with a hair band.

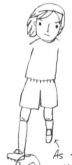

Put the arm and opposite foot forward.

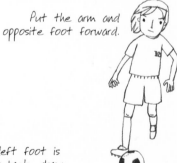

As the left foot is quite far back, draw it smaller.

1. Draw the face and the hair in a hair-band.

2. Draw the body and pants, the ball and the kicking foot, and the spikes.

3. Draw the arms that control balance.

let's draw!

A baseball player's possessions

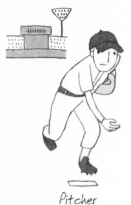

Pitcher

Cap

Bat

Let's draw a baseball player.

A soccer player's possessions

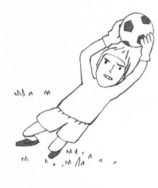

Goalkeeper

Cleats

Sports bag

Let's draw a soccer player.

teacher

She wears a proper uniform to be a good example to her students.

Part the hair at the side.

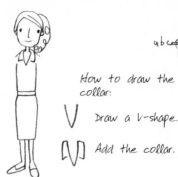

How to draw the collar:

V — Draw a V-shape.

N — Add the collar.

a b c

1. Draw the face and the neatly arranged hair.

2. Draw a shirt with a collar, her skirt, legs, and shoes.

3. Give her some chalk and a textbook.

artist

He is wearing clothes that can be stained. For him the most important thing is for his picture to be beautiful.

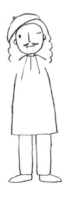

He is using his paintbrush to judge the perpendicular angle.

Make his smock a little stained.

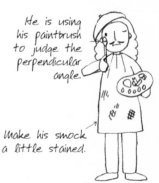

1. Draw his face, beret, and bushy hair.

2. Draw his smock, pants, and shoes.

3. Draw some stains on his smock and give him a brush and palette.

let's draw!

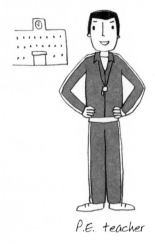

P.E. teacher

A teacher's possessions

A register

Chalk and blackboard eraser

Let's draw a teacher.

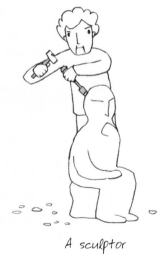

A sculptor

An artist's tools

Paints

Painting knife

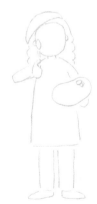

Let's draw an artist.

astronaut

The astronaut's suit is equipped with many kinds of life-support instruments.

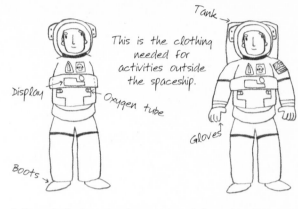

Tank

This is the clothing needed for activities outside the spaceship.

Display

Oxygen tube

Light

Gloves

Boots

1. Draw the face and helmet.

2. Draw the body, pants, boots, and space instruments.

3. Draw the gloved hands and the tank.

explorer

He is equipped with every possible instrument to deal with danger.

Draw the visor of the hat.

Draw the hat just the right size for the head to fit into.

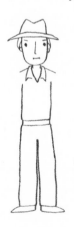

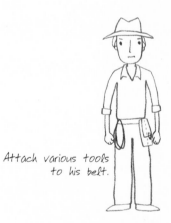

Attach various tools to his belt.

1. Draw the face, hat, and hair.

2. Draw the body, pants, and shoes.

3. Draw the hands, rope, and money pouch.

let's draw!

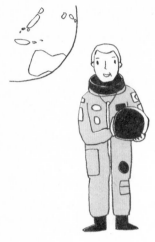

Astronauts' transport
Space shuttle

Draw an astronaut.

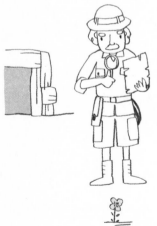

Explorer's possessions

Binoculars

Survival knife

Draw an explorer.

the frame of mind of a stylist

Try to imagine the feelings that the person you are drawing may have and think about what kind of clothing that person would like. By looking in shops and magazines and observing people on the streets, you can get gather some ideas about the various kinds of clothes there are, and it can lead to a lot of fun trying to draw them.

Blouse

T-shirt

Camisole

Cardigan

Sweater

Turtleneck

What shall I wear?

Pinafore dress

Long coat

Dress

Mini-skirt Long skirt Capri pants Jeans Cargo pants

Down jacket Bikini

Pumps

Boots

Sneakers

chapter 3 fairytale characters

there are many profound mysteries in fairytales.
let your imagine roam freely when you draw.

snow white / dwarfs

peter pan / captain hook

little red riding hood / the little match girl

alice / the queen of hearts

the little mermaid / pinocchio

cinderella / thumbelina

witch / wizard

princess kaguya / momotaro

issun boushi / urashima tarou

ogre / tengu

snow white

*She is a princess with skin as white as snow,
rose-colored lips, and hair as black as coal.*

Draw strong,
dark lines and color
the lips rose-red.

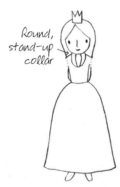
Round,
stand-up
collar

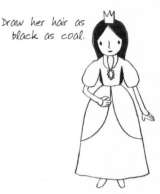
Draw her hair as
black as coal.

1. Draw her sweet face, long hair, and crown.

2. Draw her body in a dress and her shoes.

3. Draw her hands and color her hair black!

dwarfs

*The seven dwarfs get together to protect Snow White.
It is said that they study plants.*

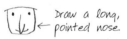
Draw a long,
pointed nose.

Draw the brim of the
hat with a pointed tip.

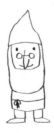

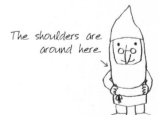
The shoulders are
around here.

1. Draw the face with a beard, glasses, and a pointed hat.

2. Draw the small body, pants, and shoes.

3. Put his hands on his hips.

let's draw!

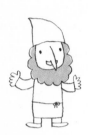
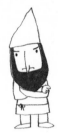
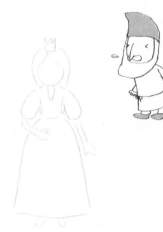

Draw Snow White.

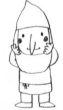
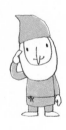
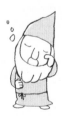

Draw the Seven Dwarfs.

peter pan

He is enjoying adventures every day in Neverland with Tinkerbell, the fairy, and the Lost Boys.

Draw only the hair that is falling across his face.

Draw the top of his head.

1. Draw his mischievous face and his hair.

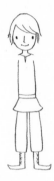

2. Draw the loose clothing on his body and his shoes.

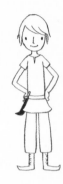

3. Put both hands on his hips and put a dagger in his belt.

captain hook

His right hand was bitten off and eaten by an alligator. He is as fierce as his appearance suggests.

First draw the brim of the hat.

Draw the moustache, which he is so proud of.

1. Draw the mean-looking face, the moustache, and the flamboyant hat.

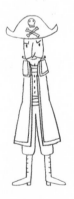

2. Draw the smart coat, pants, and shoes.

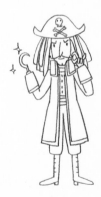

3. Draw his left hand touching his moustache, his hook for a hand, and his long hair.

let's draw!

Let's draw Peter Pan.

Let's draw Captain Hook.

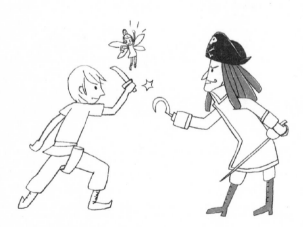

I'll fight you again today
as usual!

Victory or defeat!

little red riding hood

She took her time going to her grandmother's house and the wolf beat her to it.

The hood hides everything except the forelocks.

Her shoulders are around here.

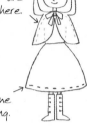

Add some cute stitching.

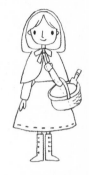

1. Draw a pretty face wearing a hood.

2. Draw her body in a cape, her skirt, and her shoes.

3. Draw her hands and give her a basket.

the little match girl

When the matches were struck, visions of a turkey, a Christmas tree, and her grandmother appeared.

Draw her red cheeks with a light touch.

Sitting

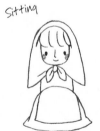

1. Draw a scarf around her head and her face looking intently at the match.

2. Draw her body in a sitting position, her shoes, and her apron.

3. Draw her hand striking a match.

let's draw!

I'm going to eat you!

Draw Little Red Riding Hood.

A Christmas tree
appears in the flame.

Draw The Little Match Girl.

alice

In order to escape boredom she chased a white rabbit and found herself in a strange wonderland.

Her sleeves are hidden behind her hair.

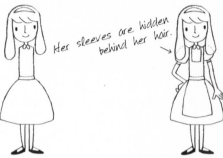

1. Draw a face full of curiosity and a hair-band.

2. Draw her body in a dress, her legs, and shoes.

3. Give her an apron and draw her hands.

the queen of hearts

She immediately sentences to death anyone she finds suspicious. Her presence is felt as she shouts, "Off with their head!"

Draw the outline of her face.

Add her hair.

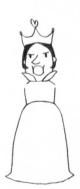

Have her point with her finger in the direction she is looking.

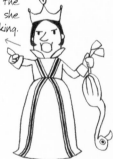

1. Draw an angry-looking face, her crown, and her collar.

2. Draw her fat body in a splendid dress.

3. Draw her hands and the pattern on her dress.

let's draw!

The Cheshire Cat

Draw Alice.

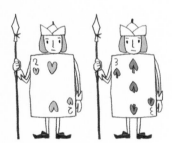

The playing-card guards

Off with her head!

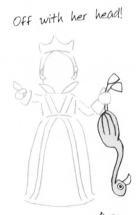

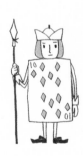

Draw the Queen of Hearts.

the little mermaid

*After falling in love with a prince, she makes up her mind
to exchange her voice for life as a human.*

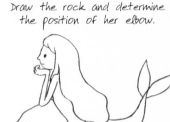

Draw the rock and determine
the position of her elbow.

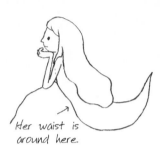

Her waist is
around here.

1. Decide the shape of her head
and draw her face and long hair.

2. Draw her arm, with the elbow,
and a smooth body—like a fish.

3. Draw her waist and tail.

pinocchio

*He hates both studying and making an effort.
He can be easily tricked using flattery.*

His nose is
his special feature.

Draw the outline of his face.

Add his hat and hair.

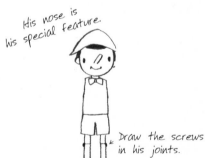

Draw the screws
in his joints.

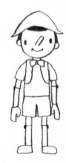

1. Draw his face with a long nose,
hat, and hair.

2. Draw his wooden body and
legs.

3. Draw his hands and jacket.

let's draw!

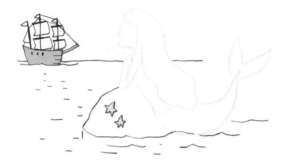

Let's draw The Little Mermaid.

Let's draw the nose that grows longer and longer.

Let's draw Pinocchio.

cinderella

With a magic spell, the pumpkin becomes a carriage, mice become horses, and lizards become footmen.

Position it a little diagonally.

Give her ribbons, a necklace, and a fan to dress her up nicely.

1. Draw a cute face, arranged hair, and a small decorative hat.

2. Draw her body in a beautiful dress and her glass slippers.

3. Draw her hands holding a fan and accessories.

thumbelina

She is a tiny little girl born in a tulip. She has a problem with so many animals liking her.

Draw the center first.

Sitting

1. Draw her cute face and hair and the decorative flower.

2. Draw her body in a dress and her legs.

3. Put her hands on her knees and draw the stitching around her waistline.

let's draw!

I want to go to the ball as well.

Glass slipper

Let's draw Cinderella.

A swallow

Let's draw Thumbelina.

witch

Although most of the witches that appear in stories are bad, there must be good witches as well.

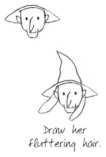

Draw her
fluttering hair.

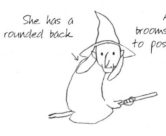

She has a
rounded back

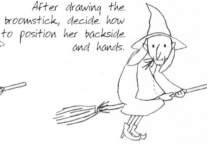

After drawing the
broomstick, decide how
to position her backside
and hands.

1. Draw her face with a pointed nose, a her triangular hat, and her hair.

2. Draw the broomstick and her hands grasping it.

3. Draw her legs hanging down and the end of the broom.

wizard

The wizard does not only use magic, but also he uses his deep insight to fulfill his role as a guide in people's lives.

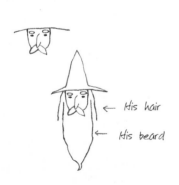

← His hair

← His beard

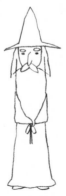

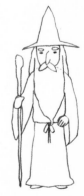

1. Draw his face with a splendid beard, his long hair, and his triangular hat.

2. Draw his clothes tied with a drawstring and his shoes.

3. Draw big sleeves and a magic wand in his hands.

let's draw!

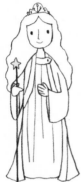

Good witch

Black cat

Let's draw a witch.

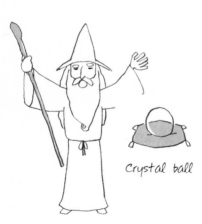

Abracadabra!

Crystal ball

Let's draw a wizard.

princess kaguya

Just before returning to the moon, Princess Kaguya sent the mikado (emperor) medicine to live eternally, a celestial robe of feathers, and a letter.

Her eyebrows are shaved.

First draw the eyebrows and then, after that, the hair that lies above them.

Draw several layers on top of each other.

Add some more disheveled hair.

1. Draw a sorrowful face, shoulders, and long hair.

2. Draw her seated, kimono-clad body and her hands.

3. Draw her layered kimono and her long, flowing hair.

momotaro

When he charmed the dog, monkey, and pheasant his millet dumplings must have tasted wonderful.

Decide the position of the hairline.

Give him a bird hat.

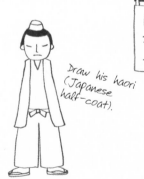

Draw his haori (Japanese half-coat).

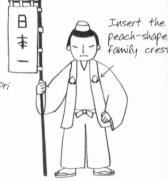

Insert the peach-shape family crest

1. Draw a clean-cut face, hair, and a bird hat.

2. Draw a kimono-clad body and legs.

3. Draw his hand holding a banner.

let's draw!

Let's draw Princess Kaguya.

Dog

Monkey

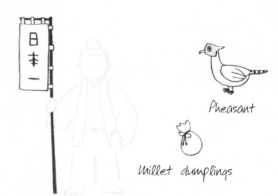

Pheasant

Millet dumplings

Let's draw Momotaro.

issun boushi

Using a bowl as a boat, chopsticks as oars, and a needle as a sword, he went to the capital city.

Just shave this part.

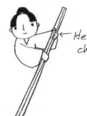

← He's holding the chopstick oars.

Standing firm

1. Draw a small face, the forelocks, and topknot.

2. Draw his kimono and the oar and his hands holding it.

3. Draw his legs in a hakama (Japanese skirtlike garment) and his arms.

urashima tarou

There were many stories after he opened the treasure chest and became an old man, and we are not sure which is true or not.

Tie the hair back a little.

Hold onto the turtle with the left hand.

Carry the treasure chest under one arm.

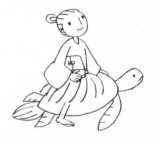

1. Draw the face looking up and the hair.

2. Draw his kimono and his arm around the treasure chest.

3. Draw the turtle, his straw raincoat, and his legs.

let's draw!

Magic mallet

Hey, I'm ready!

Let's draw Issun Boushi.

Puff, puff

Let's draw Urashima
Tarou.

ogre

He has horns and tiger fangs and wears a tiger skin.
When he holds an iron club he is invincible.

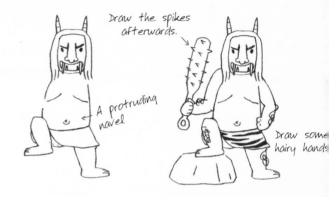

Draw the big nose and fangs.

His horns are his special feature.

Draw the spikes afterwards.

A protruding navel

Draw some hairy hands

1. Draw his square face and big nose, mouth, fangs, and horns.

2. Draw the body in tiger skin and fat legs.

3. Add his fat arms, an iron club, and the tiger-skin pattern.

tengu

Although he has a scary face, it is said that he protects the mountains. His clothes resemble that of a hermit priest.

He has a long nose.

Give him a skullcap.

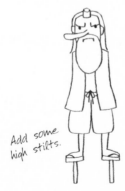

Add some high stilts.

He holds a fan made from feathers.

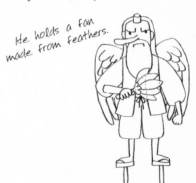

1. Draw a long nose on his stern face, a beard, and hat.

2. Draw his vest and a hakama and his feet standing on some high stilts.

3. Draw his hand holding a fan and wings.

let's draw!

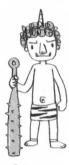

Baby ogre

Let's draw an ogre.

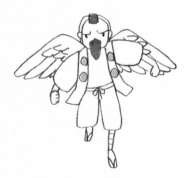

Crow Tengu

Let's draw Tengu.

tips for drawing portraits

When you look at someone or recall them, what do you feel is the main feature that stands out? If you focus on that one feature, it is strange the way the whole picture comes to resemble the person. Have a look at the pictures below as a reference.

face illustration guide

Various face shapes

Round Long Chubby

Triangular Square Pentagonal

Various eyes

Wide-open Looking down Looking up

Heavy eyebrows Calm Small eyes

Various noses

Key-shaped nose Long nose Dumpling nose

Pig nose Small nose Turned-up nose

Various mouths

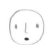 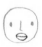 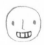

Pursed lips Thick lips Tee, hee, hee

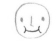

Chubby cheeks Older Nihilistic

what kind of people are around you?

Coffee shop owner

The old man next door

Cool older friend

The exchange student

The girl working
in the Indian restaurant

The woman working
in the barbershop

One of the local kids

A receptionist

Piano teacher

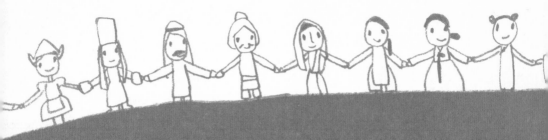

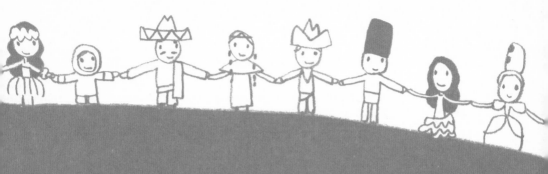

chapter 4 world clothing

*one can appreciate the history and way of life
of different countries by observing the many kinds
of clothing that exist throughout the world.*

japanese / chinese
korean / vietnamese
hawaiian / eskimo
dutch / french
spanish / mexican

japanese clothing

The Japanese kimono makes the contours of the body appear straight.

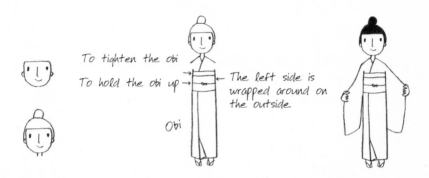

To tighten the obi

To hold the obi up →

The left side is wrapped around on the outside.

Obi

1. Draw the face and the Japanese traditional hairstyle.

2. Draw the kimono-clad body and *zori* (Japanese sandals).

3. Draw the long sleeves and color the hair black.

chinese clothing

The special features of the Chinese dress are a high collar, a slit, and decorative buttons.

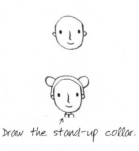

Draw the stand-up collar.

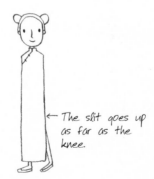

← The slit goes up as far as the knee.

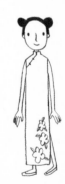

1. Draw the face and the hair tied up in two bunches.

2. Draw her body wearing a Chinese dress, her legs, and her shoes.

3. Draw her hands and color her hair black.

let's draw!

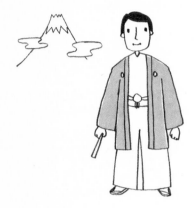

Japanese accessories

Ornamental
hairpin

A draw-string bag

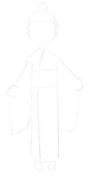

Let's draw a woman
wearing a kimono.

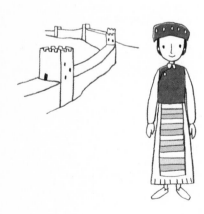

Chinese possessions

A tea cup

Nunchaku

Let's draw a woman
wearing a Chinese dress.

korean clothing

The elegant line and diverse shades of color used in the Chimachogori make it into a beautiful costume.

The upper-dress (Chogori) is worn over the skirt (Chima).

A ribbon is tied in a circle on only one side.

There is a cute pattern around the hem.

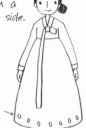

1. Draw her face and hair arranged at the back.

2. Draw her body wearing the Chimachogori.

3. Draw her sleeves and hands and the pattern along the edge of the Chimachogori.

vietnamese clothing

The origin of the Chinese dress comes from the Aozai. It goes well with the trousers worn underneath.

Draw an upright collar.

Here is a slit right up to the waistline so it does not get in the way when walking.

1. Draw her face and the hair tied back tightly.

2. Draw her body in an Aozai and shoes.

3. Draw her sleeves and hands.

let's draw!

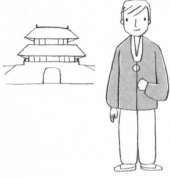

Menswear is called
Paji (pants)-chogori

Korean food

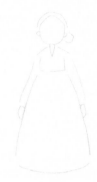
Kimuchi

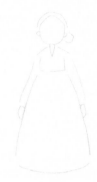

Let's draw a girl
wearing a Chimachogori.

Vietnamese
transportation

Rickshaw

Let's draw a woman
wearing an Aozai.

hawaiian clothing

The dress used for hula dancing emphasizes the special swinging dance movement of the hips.

Weight is put on the right foot and the hips swing to the left.

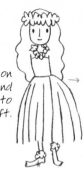

Palms of both hands face downwards.

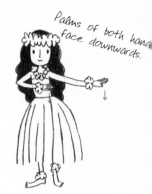

1. Draw a lei (Hawaiian flower garland) on her head and her long hair.

2. Draw her body in a skirt made from Hawaiian Ti leaves, a lei, and her legs.

3. Draw the hand movement of her dancing the hula and color her hair black.

eskimo clothing

The coat is made from caribou and sealskin.

Wrapped in a warm hood

Rosy cheeks

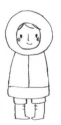

Draw the fur of the coat.

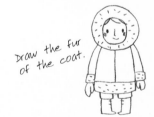

1. Draw a round face in a hood.

2. Draw the body in a warm fur coat and the legs.

3. Draw the hands and the fur of the coat.

let's draw!

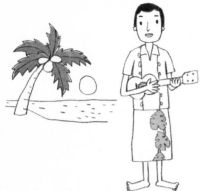

Hawaiian plants

Monstera

Hibiscus

Let's draw a girl
hula-dancing.

An Eskimo's possessions

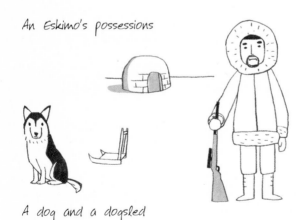

A dog and a dogsled

Let's draw an
Eskimo child.

dutch clothing

They wear wooden clogs called klompen that are suitable for walking on the damp earth.

Give her a triangular hat.

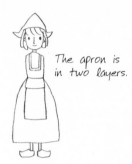

The apron is in two layers.

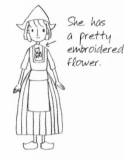

She has a pretty embroidered flower.

1. Draw her face and the hair arranged high up.

2. Draw her body wearing an apron and her wooden clogs.

3. Draw her hands and the pattern on her clothes.

french clothing

The dress has lots of beautiful gold embroidery and decorations on it, and the waist is accentuated by a corset.

The high arranged hair looks chic.

How to draw a rose

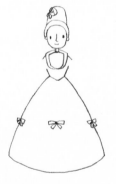

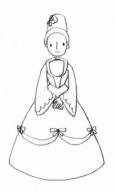

1. Draw her face, her head decoration, and her hair.

2. Draw a low-cut dress with a ballooning skirt.

3. Draw her hands and decorations.

let's draw!

Dutch possessions

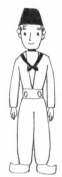

Clogs

Let's draw a Dutch girl.

French loaves

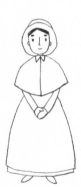

The wide one is called Parisian.

The long thin one is a baguette.

Let's draw a French Princess.

spanish clothing

The matador wears an outfit that shines with gold embroidery.

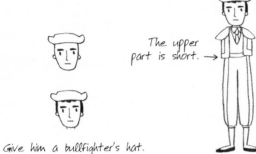

Give him a bullfighter's hat.

The upper part is short. →

He is holding the whip and his cloak ↓

1. Draw his head in a hat.

2. Draw his waistcoat and top clothes, pants, and shoes.

3. Draw his hand holding his equipment and the pattern on his clothing.

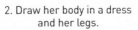

mexican clothing

The skirt is characterized by its bright colors and the way it fans out fully when she twirls.

Plenty of material is used in the skirt.

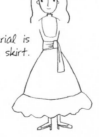

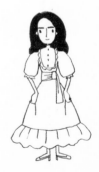

1. Draw her face with thick eyebrows and long hair.

2. Draw her body in a dress and her legs.

3. Draw the frilly part of her dress and her hands and then color her hair black.

let's draw!

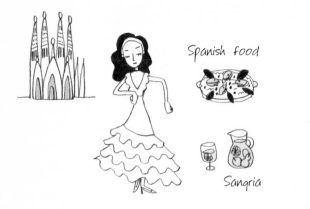

Spanish food

Sangria

Try to draw a matador.

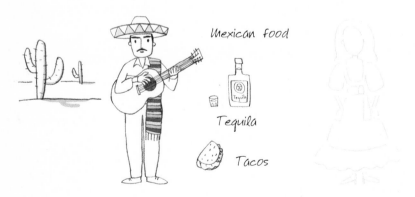

Mexican food

Tequila

Tacos

Try to draw a Mexican girl.

arabian clothing

The Arabian costume consists of a scarf worn on the head and a long shirt from the shoulders to the ankles.

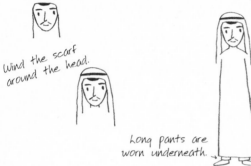

Wind the scarf around the head.

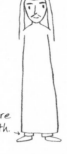

Long pants are worn underneath.

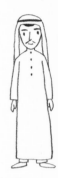

1. Draw his head wearing a scarf.

2. Draw the long shirt and his legs.

3. Draw his arms in long sleeves and button him up.

scottish clothing

The kilt that is wrapped around the waist is not a skirt. Each family has a different pattern on their kilt.

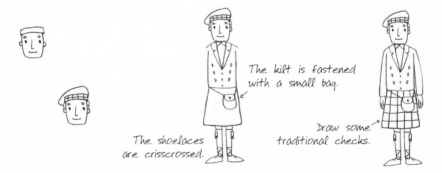

The kilt is fastened with a small bag.

The shoelaces are crisscrossed.

Draw some traditional checks.

1. Draw his head wearing a hat.

2. Draw his jacket and kilt and his legs sporting the long socks.

3. Draw his hands and the checked pattern.

let's draw!

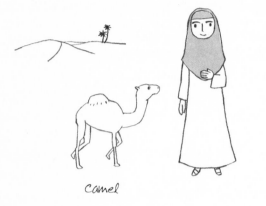

Camel

Let's draw an Arabian man.

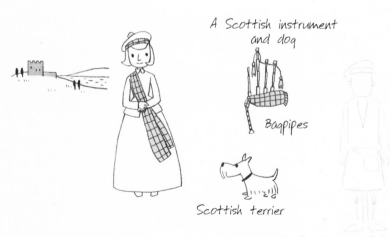

A Scottish instrument and dog

Bagpipes

Scottish terrier

Let's draw a Scottish man.

russian clothing

The fur hat is called a shapka and the one with the earmuffs is known as an ushanka.

Draw the brim of the pulled-down hat.

1. Draw the head wearing a fur hat.

After drawing the upper clothing add the hair

2. Draw the fur collar and his upper body with his hands inside a muffler.

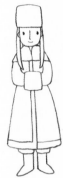

3. Draw his long coat and boots.

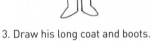

indian clothing

Five meters of the sari cloth is wrapped around the body and the rest is draped across the shoulders.

Put the decoration on her forehead.

1. Draw the face with the Hindu decoration.

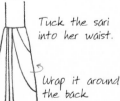

The sari covers the area from the middle of the head and is draped forward.

Tuck the sari into her waist.

Wrap it around the back

2. Draw the shirt on the upper body and the sari wrapped around her legs.

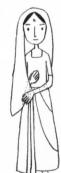

3. Draw the sari covering her head and her hands.

let's draw!

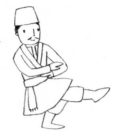

Russian dolls
Matrioshika

Let's draw a Russian girl.

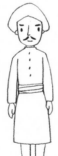

Hindu ornaments

Let's draw an Indian girl.

english clothing

The uniform worn by English guards consists of
a red jacket and a bearskin hat.

Put a bearskin hat
on his head.

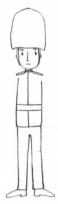

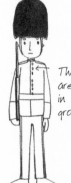

The buttons
are arranged
in different
groups.

1. Draw a long hat on his head.

2. Draw his upper body in a
jacket, his pants, and his shoes.

3. Draw a rifle in one of his
hands and color in the
hat in a fluffy way.

american clothing

He wears a cowboy hat, a western shirt, and western boots.

After drawing →
his shirt, add the
strings hanging down.

The brim is facing
upwards.

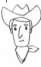

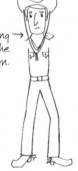

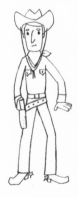

1. Draw his head in a hat
and his scarf.

2. Draw his shirt with jeans
and boots.

3. Draw his gun belt, pistol,
and hands.

let's draw!

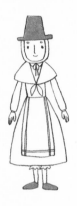

English transport
A double-decker bus

Let's draw an English guard.

American food
Hamburgers

Native American

Let's draw a cowboy.

epilogue gallery

Try adding some colors
to the illustrations.
You do not have to
use realistic colors!

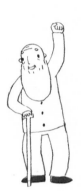

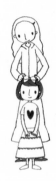

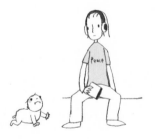

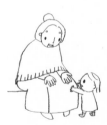

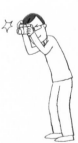

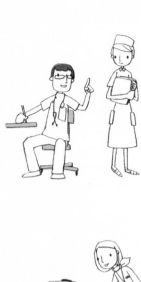
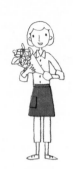
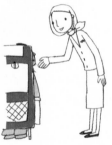
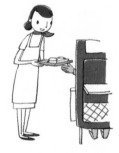
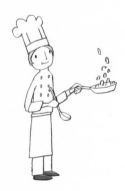
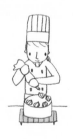
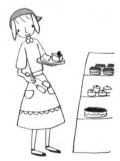

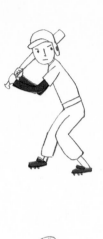

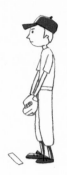

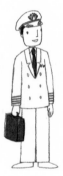

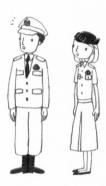

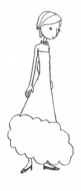

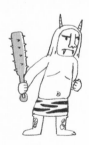
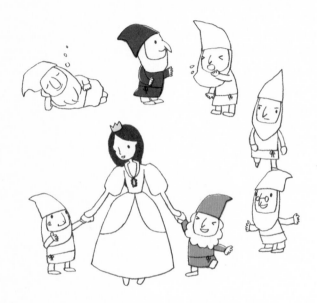

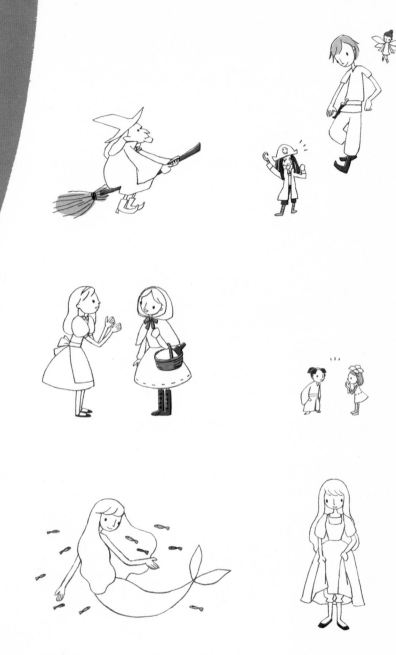

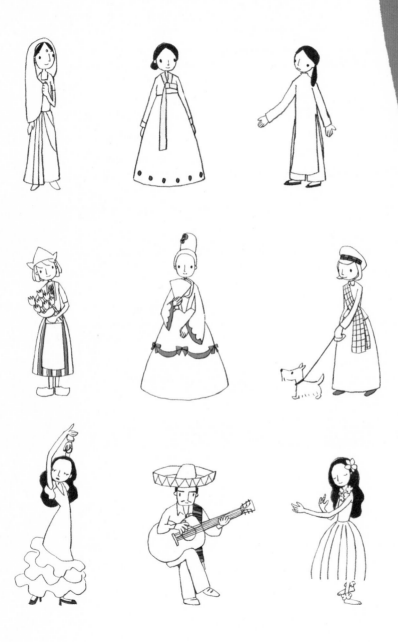

Fin

about the author

Sachiko Umoto graduated with a degree in oil painting from Tama Art University in Tokyo, Japan. In addition to her work as an illustrator, she also produces animation for USAGI·OU Inc. She is the author of *Illustration School: Let's Draw Plants and Small Creatures and Illustration School: Let's Draw Cute Animals* (both originally published in Japan by BNN, Inc.). She dearly loves dogs and Hawaii.

 Visit her online at http://umotosachiko.com.